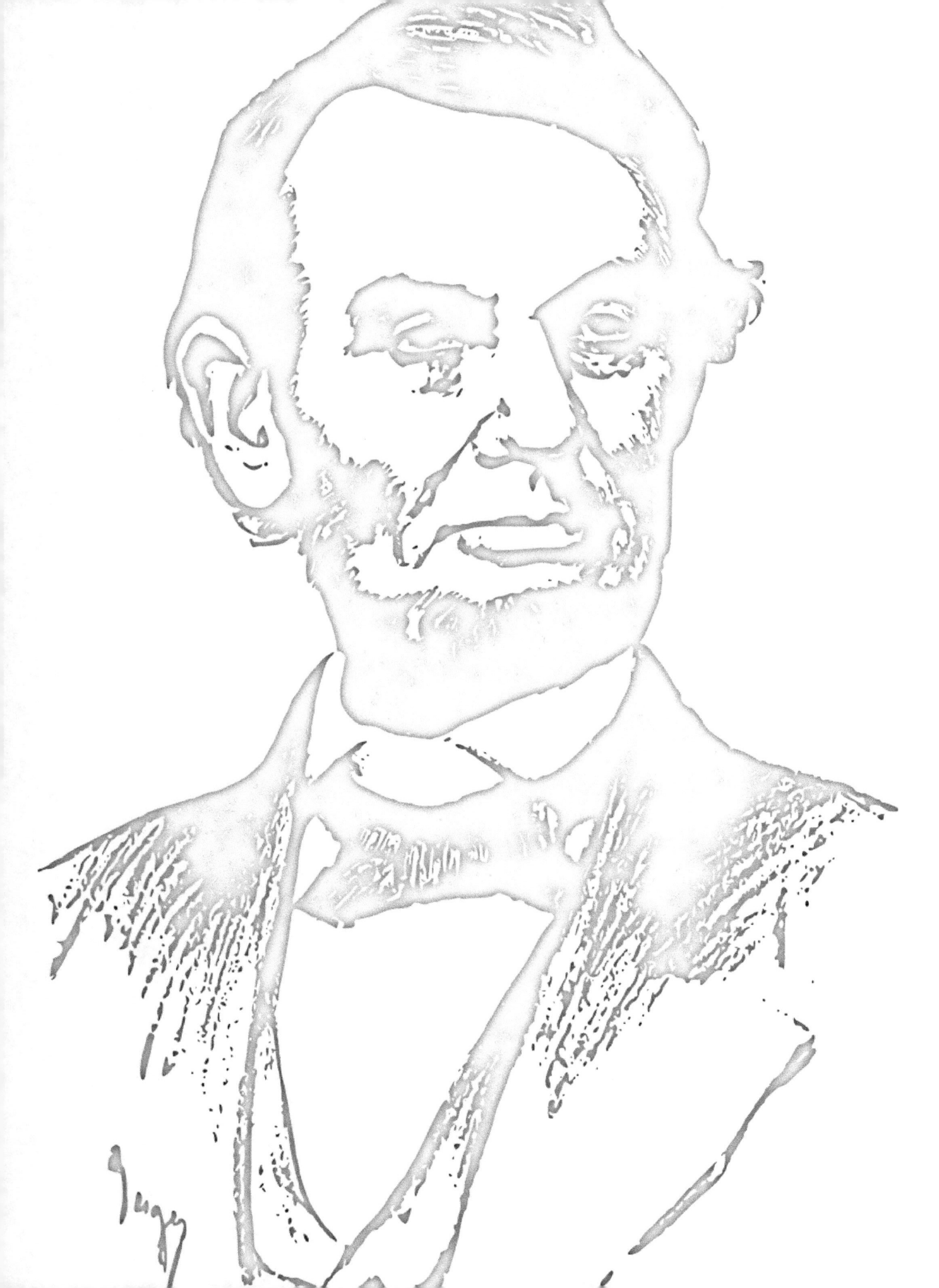

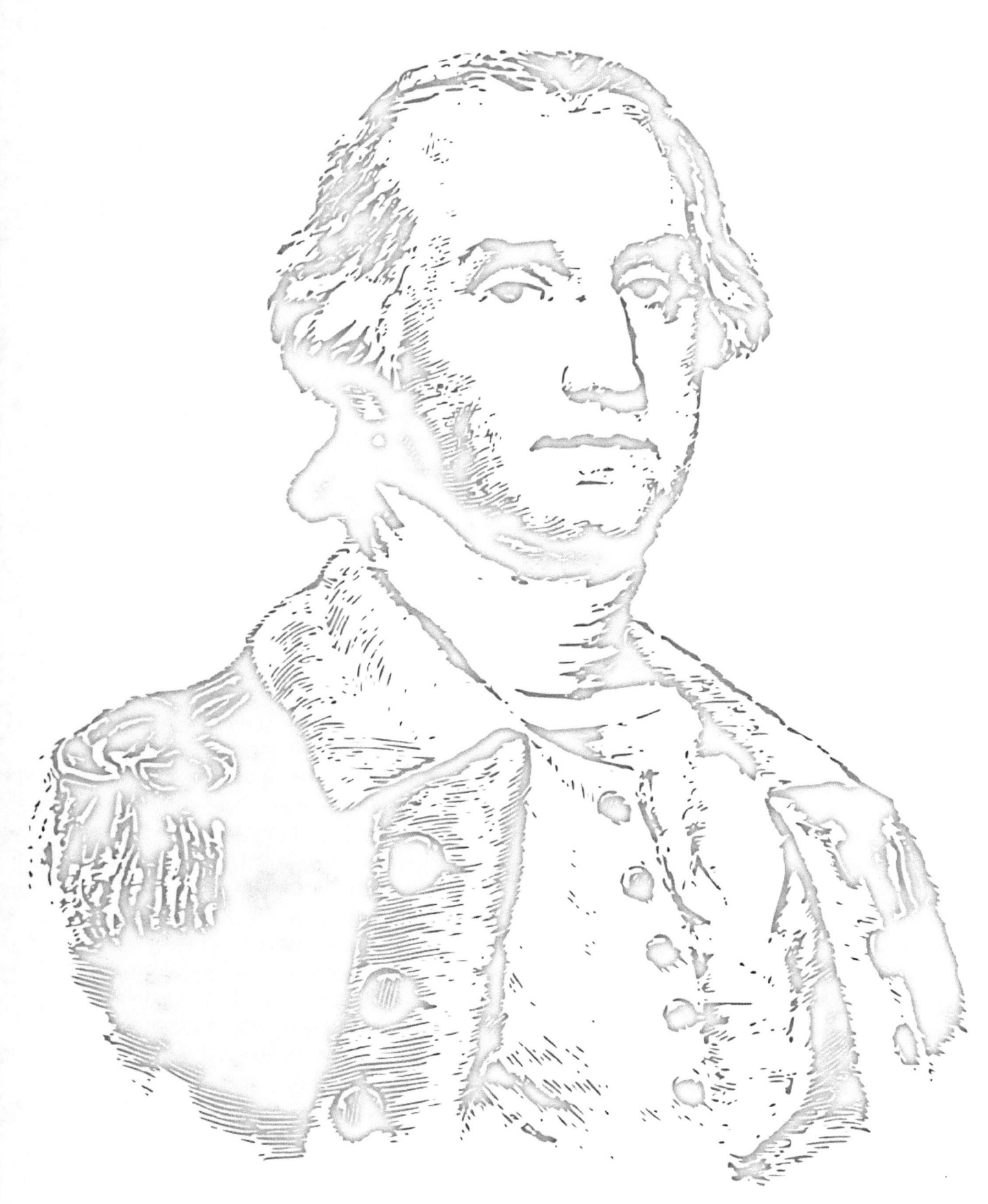

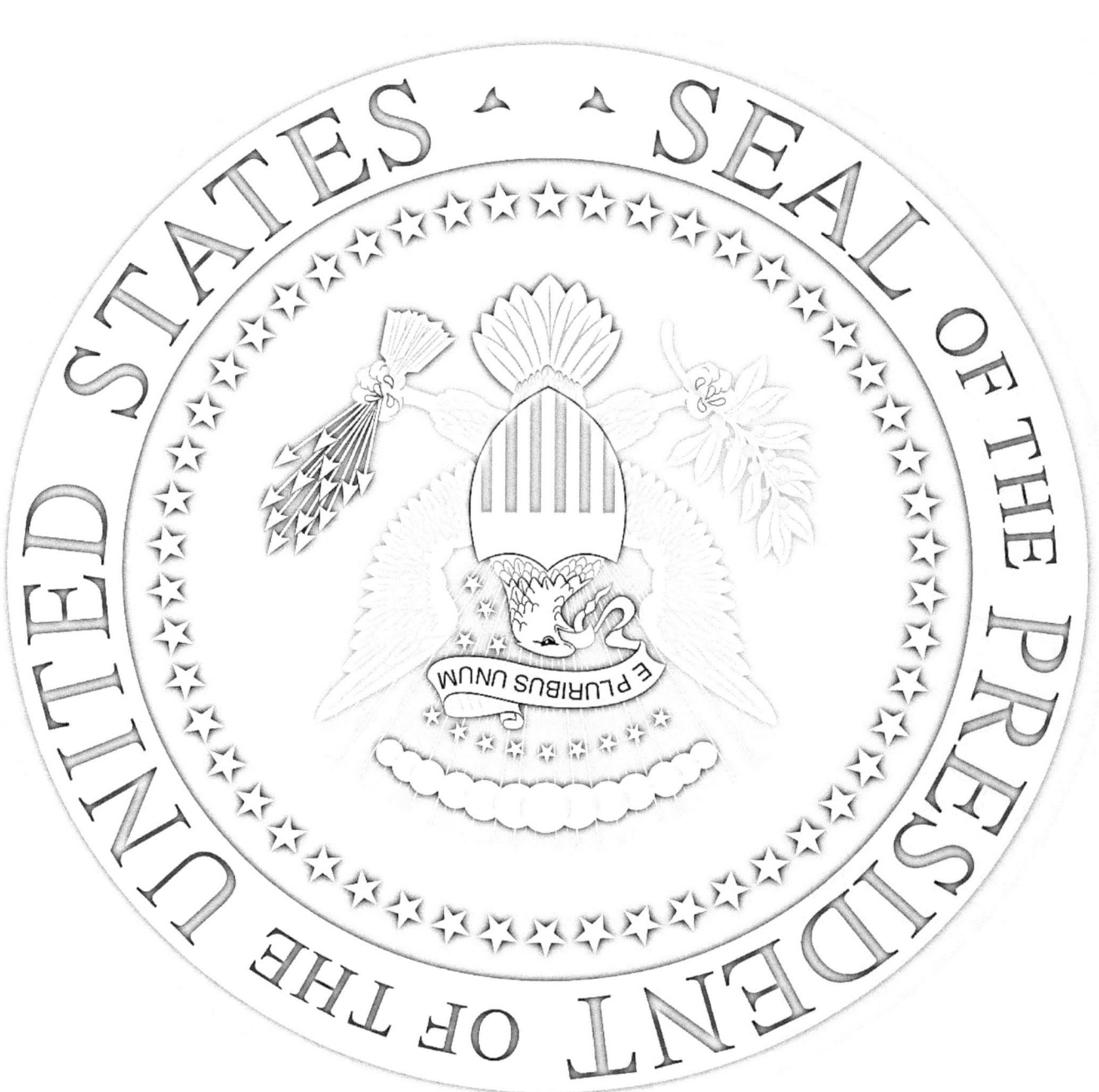

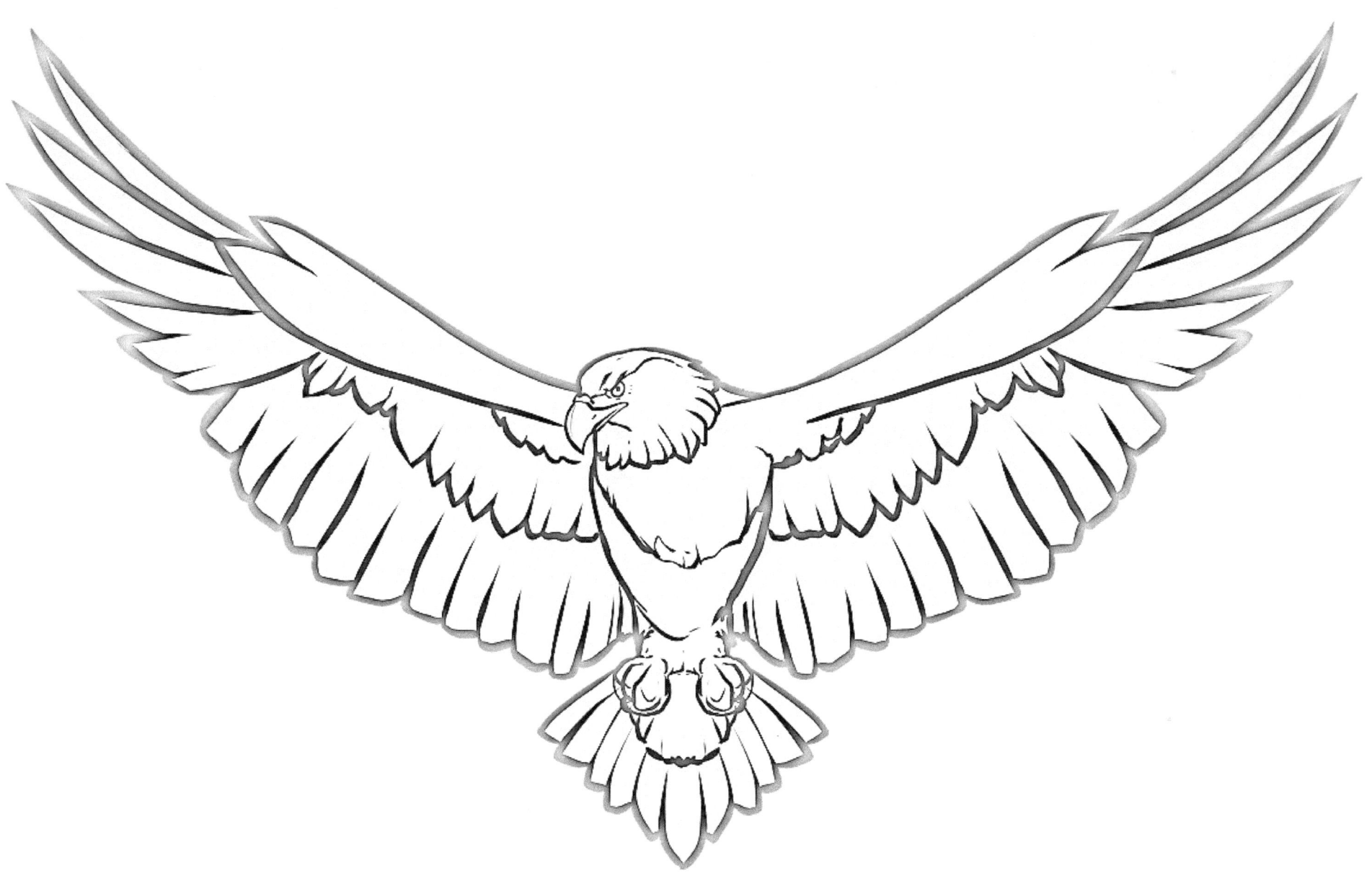

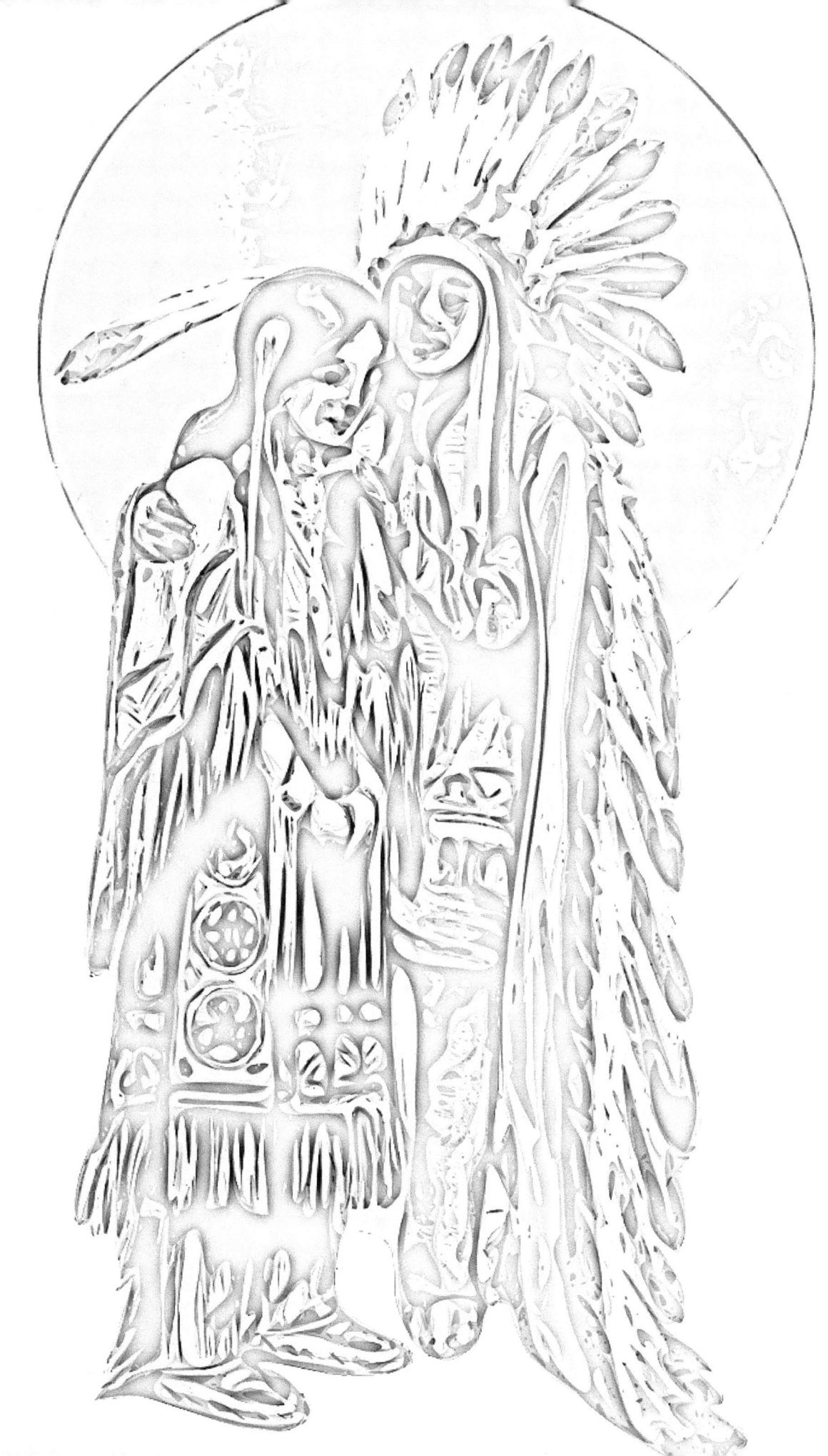

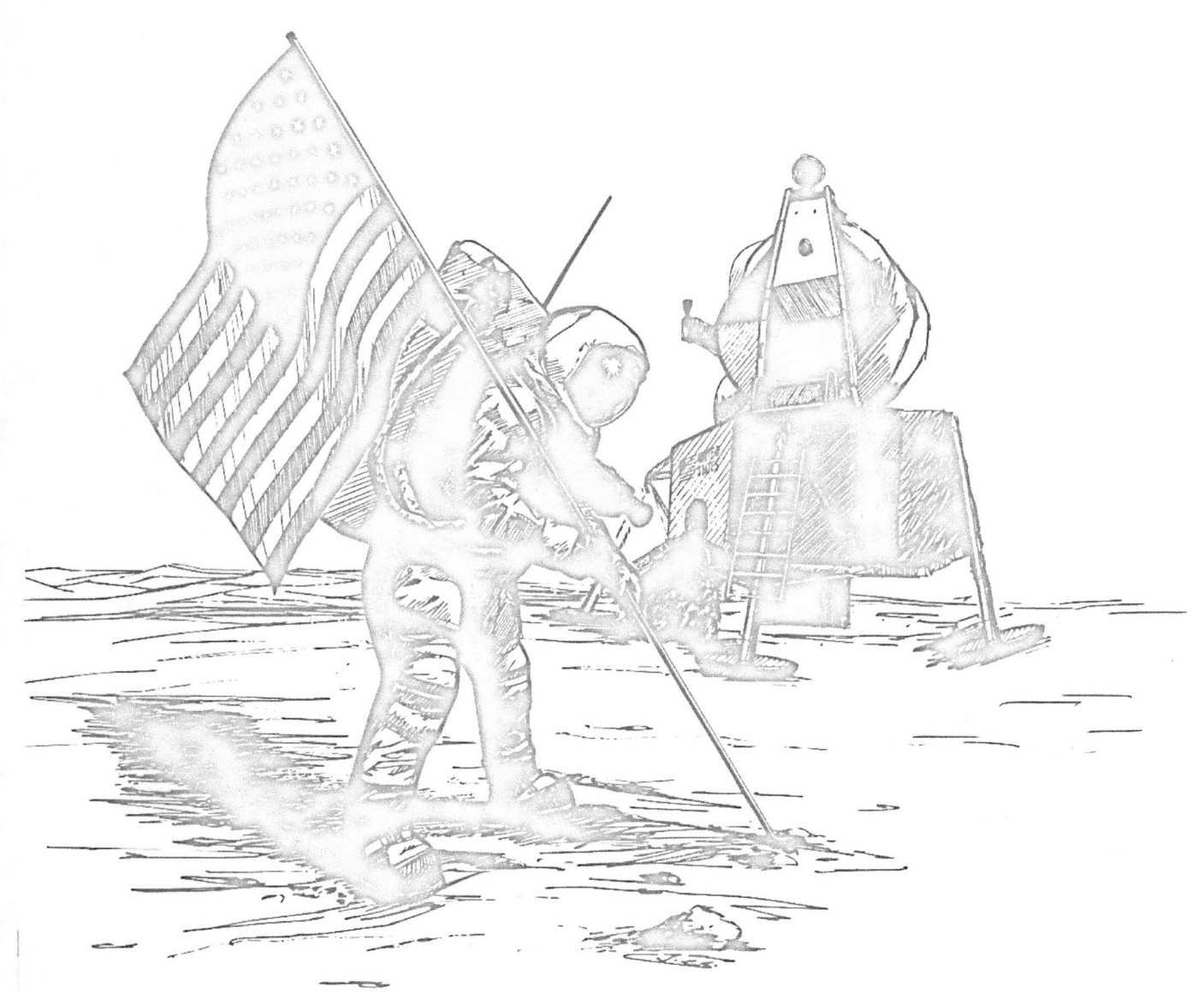

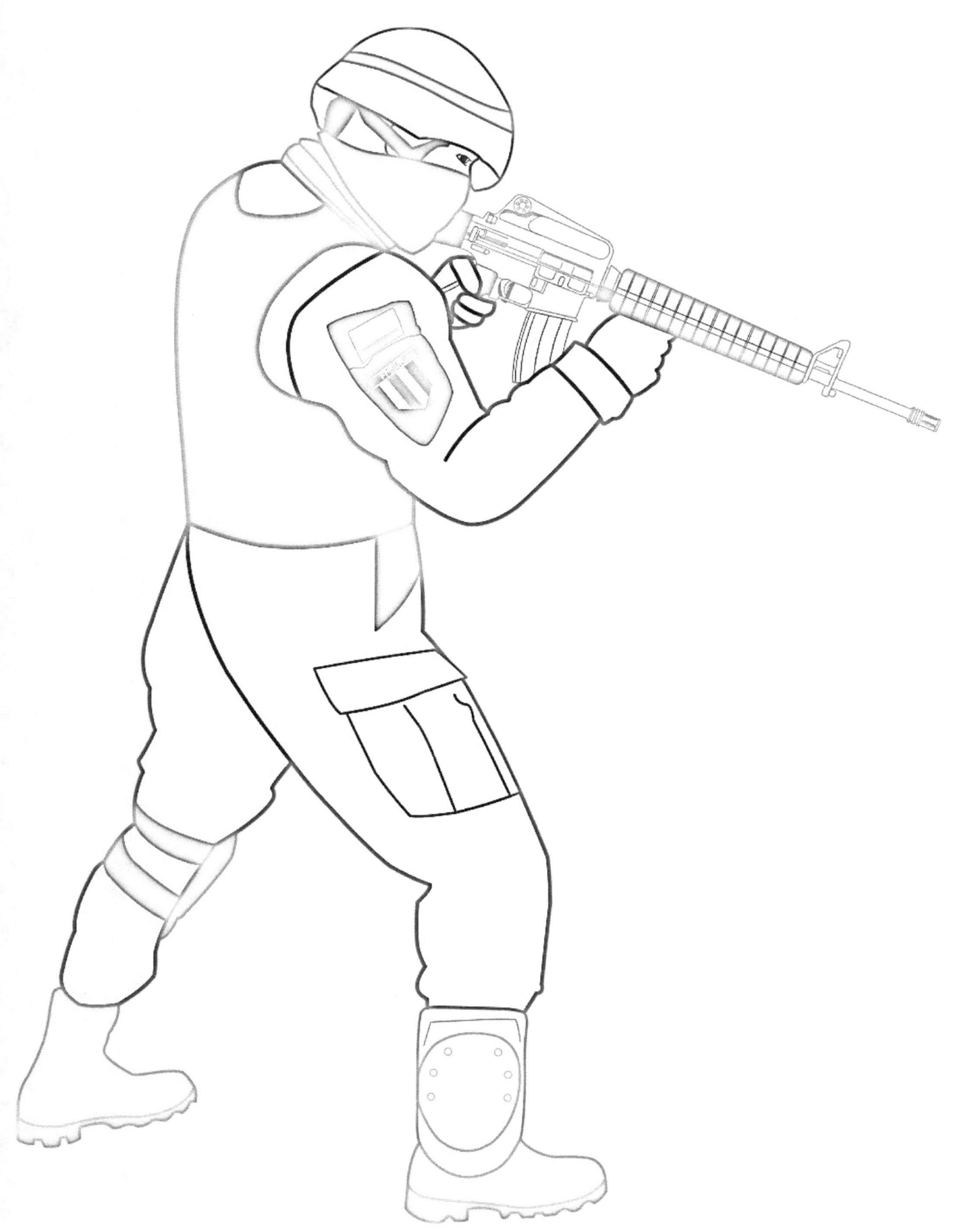

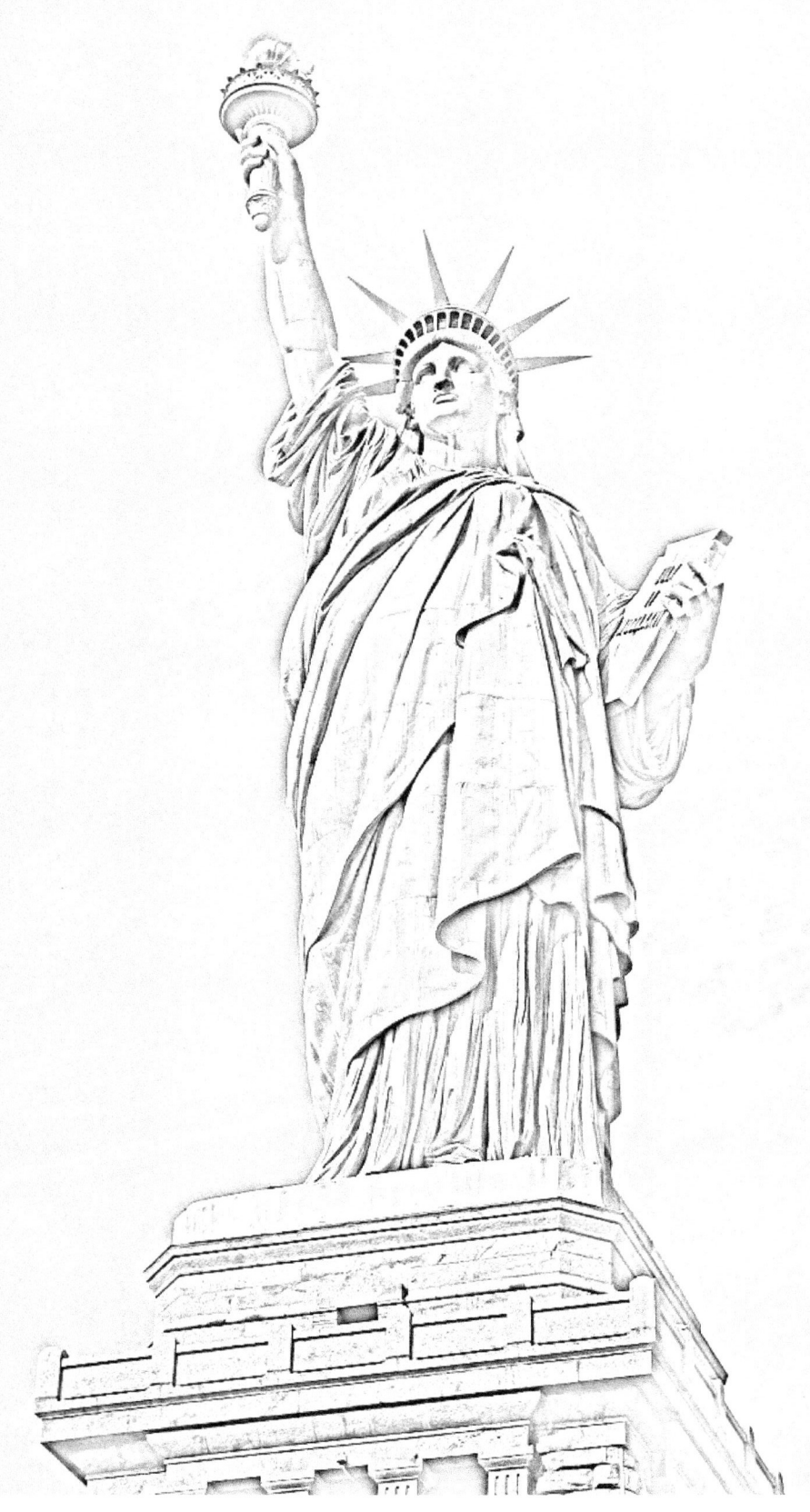

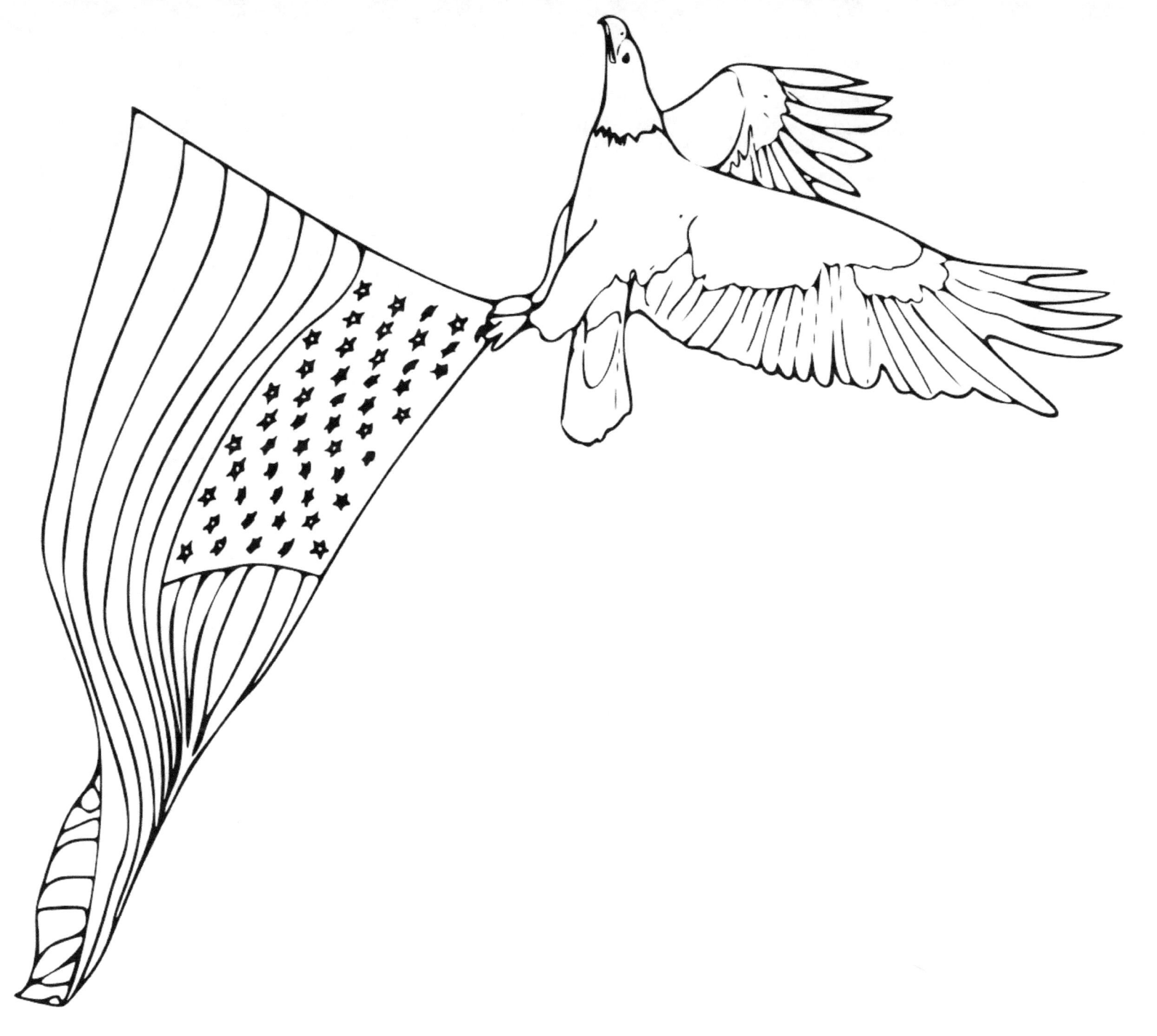

I AM AN AMERICAN SOLDIER
I AM A WARRIOR AND A MEMBER OF A TEAM
I SERVE THE PEOPLE OF THE UNITED STATES
I WILL ALWAYS PLACE THE MISSION FIRST
I WILL NEVER ACCEPT DEFEAT
I WILL NEVER QUIT
I WILL NEVER LEAVE A FALLEN COMRADE
I AM A GUARDIAN OF FREEDOM AND
THE AMERICAN WAY OF LIFE
I AM AN AMERICAN SOLDIER

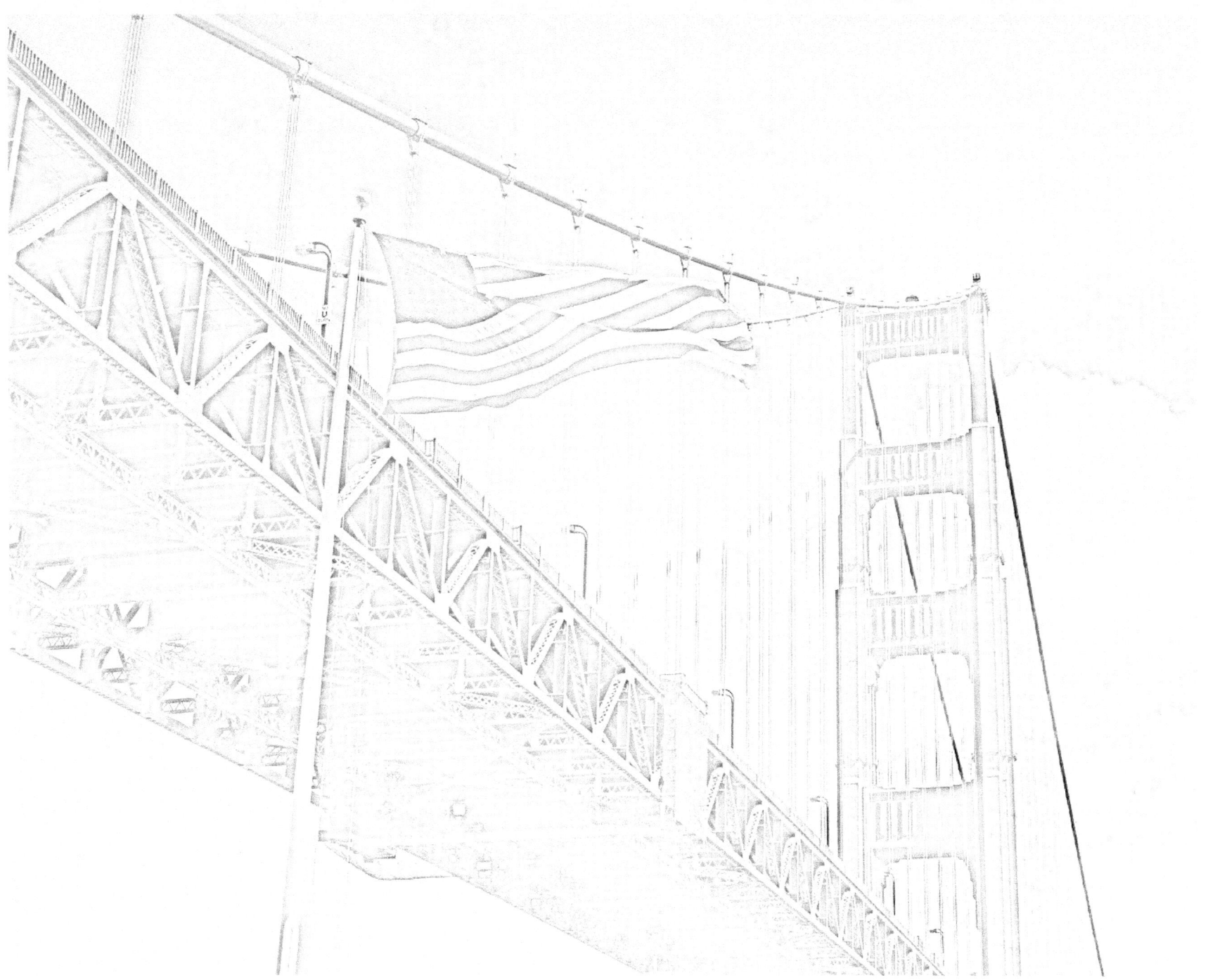

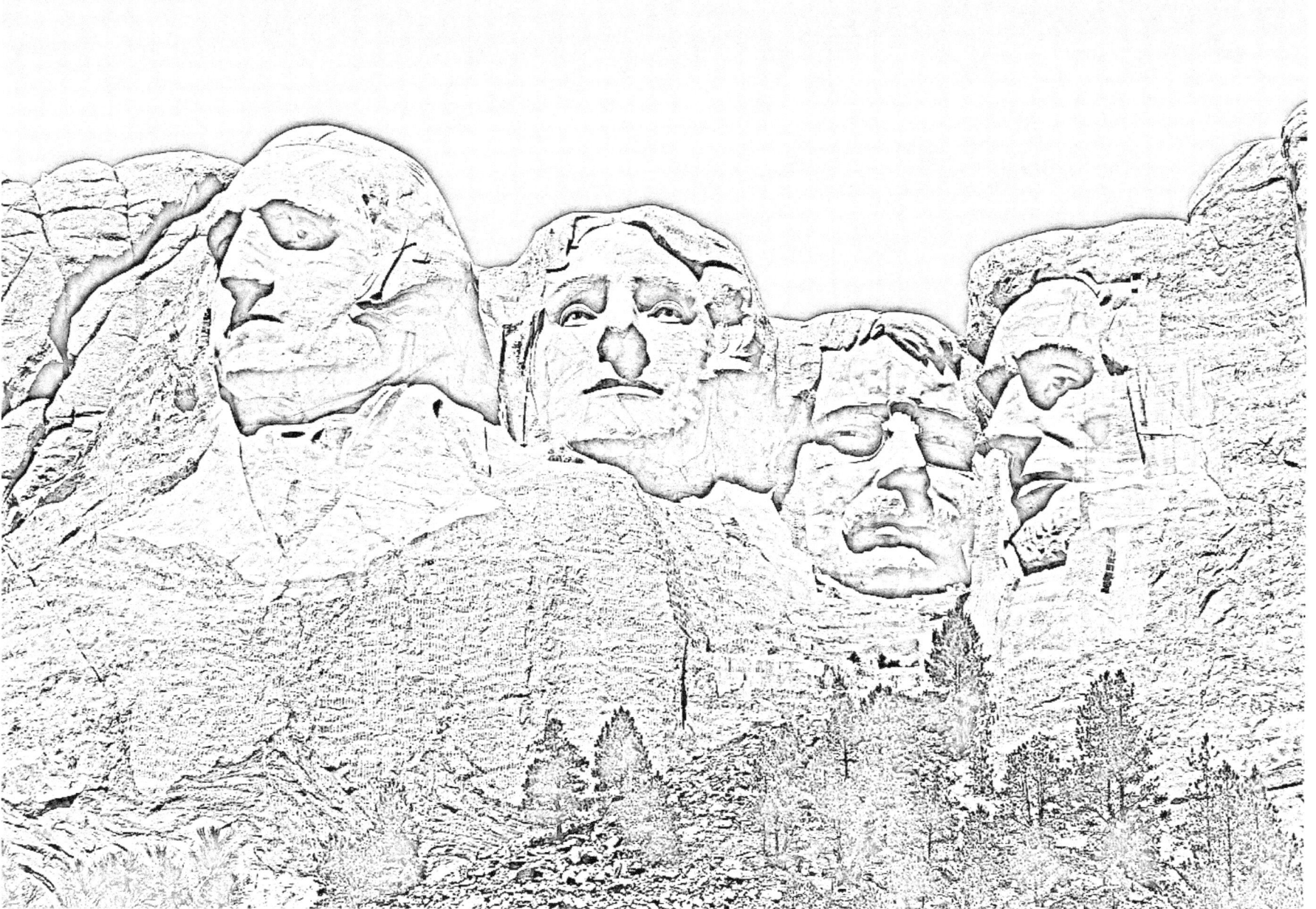

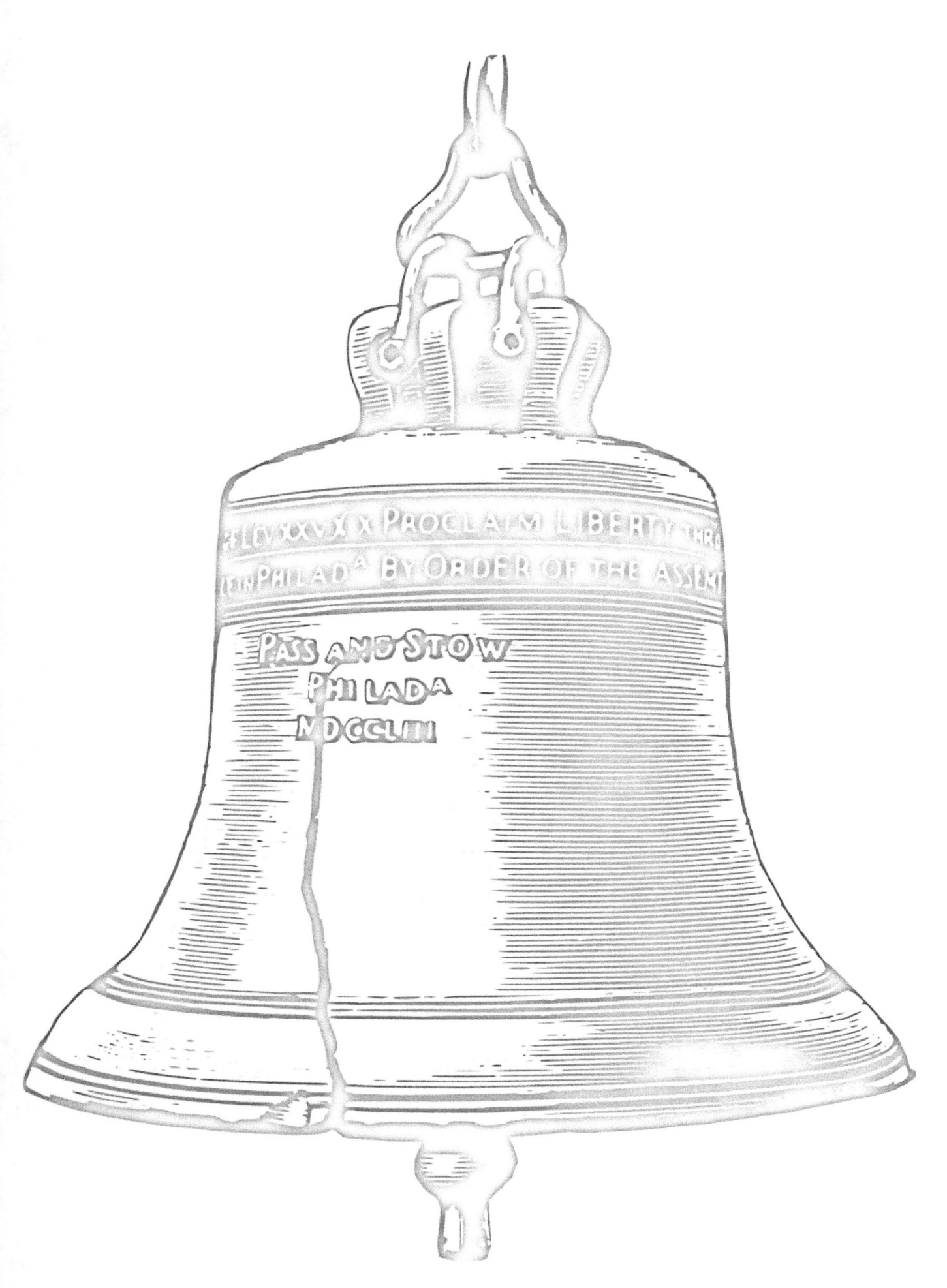

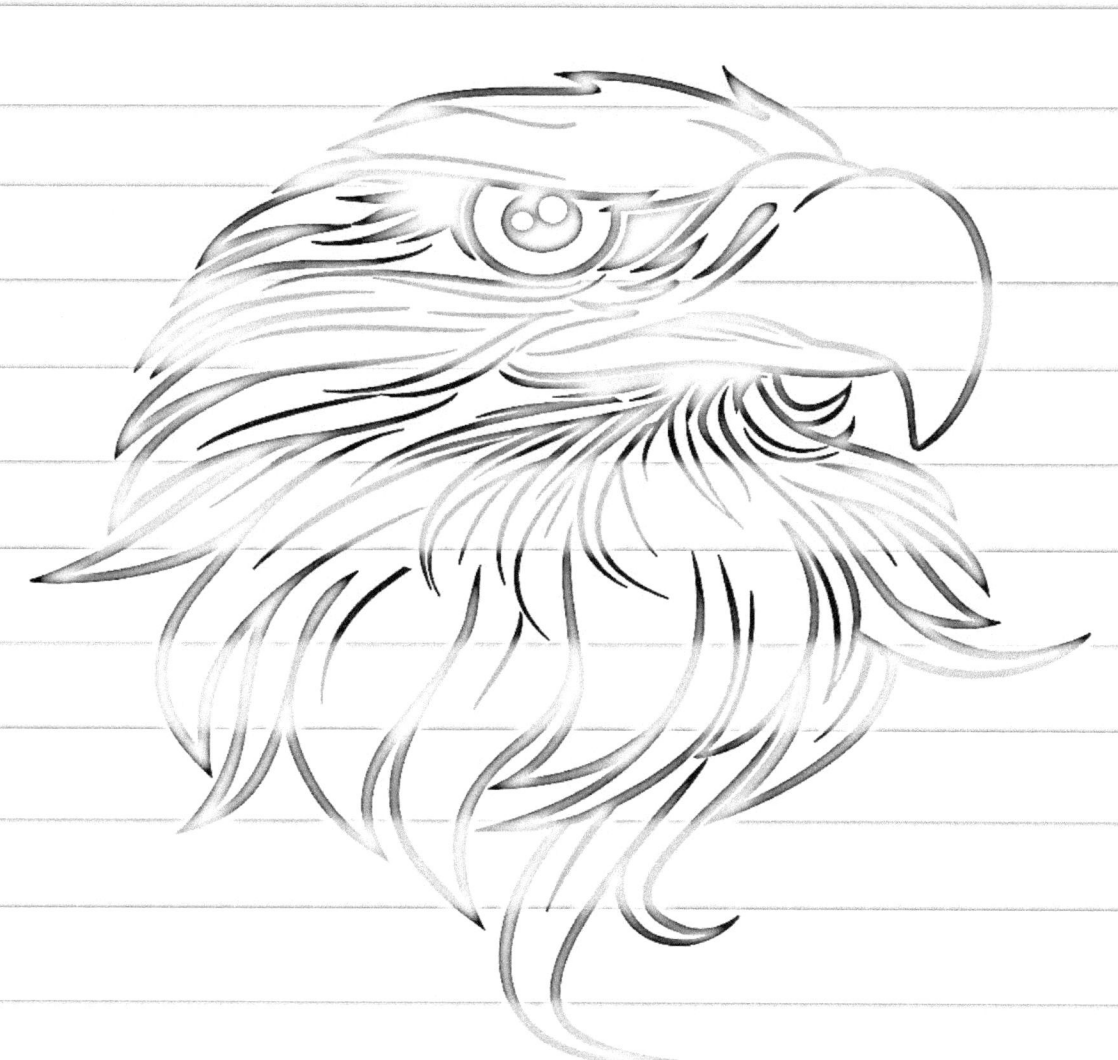

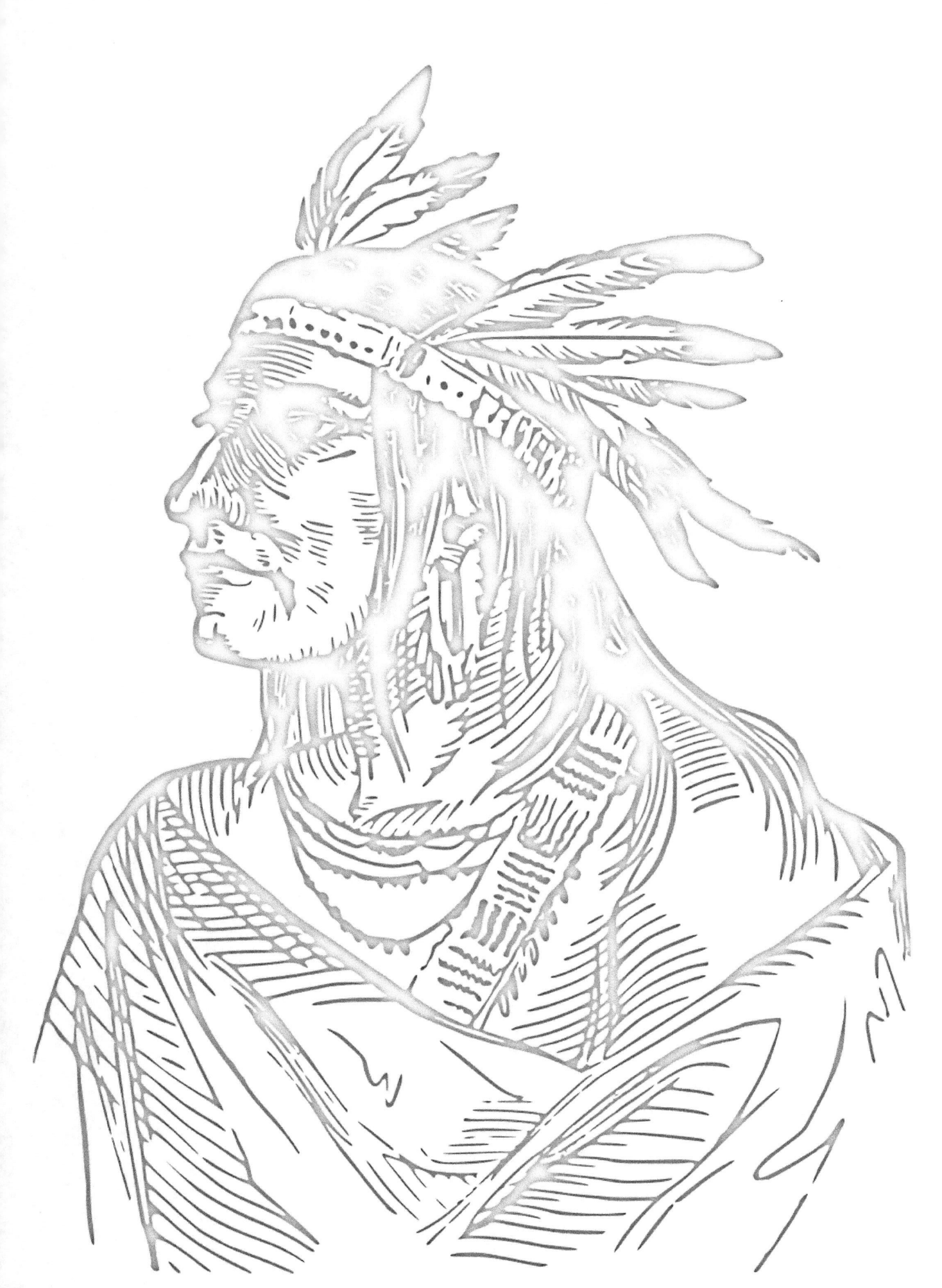

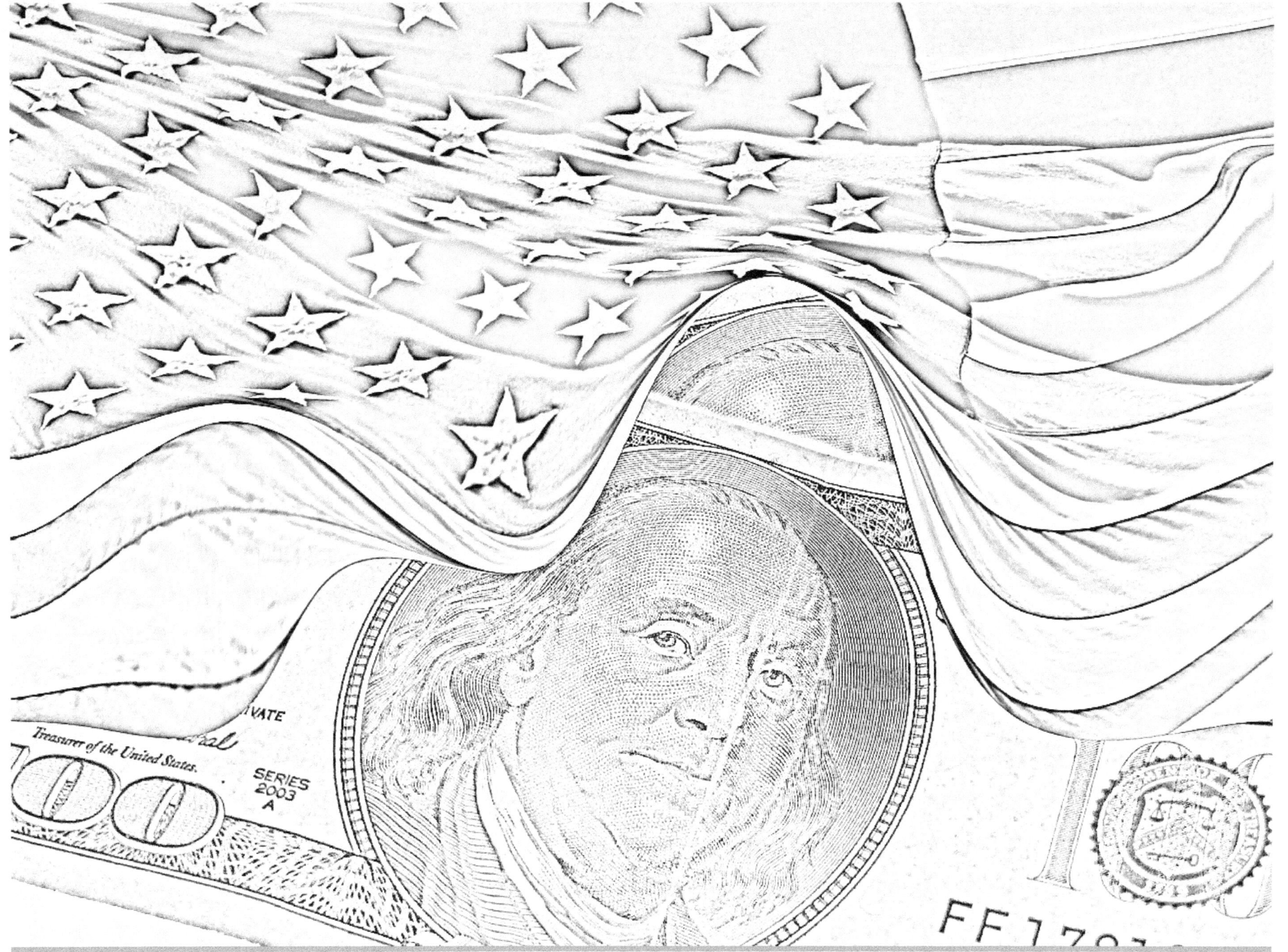

IN THIS TEMPLE
AS IN THE HEARTS OF THE PEOPLE
FOR WHOM HE SAVED THE UNION
THE MEMORY OF ABRAHAM LINCOLN
IS ENSHRINED FOREVER

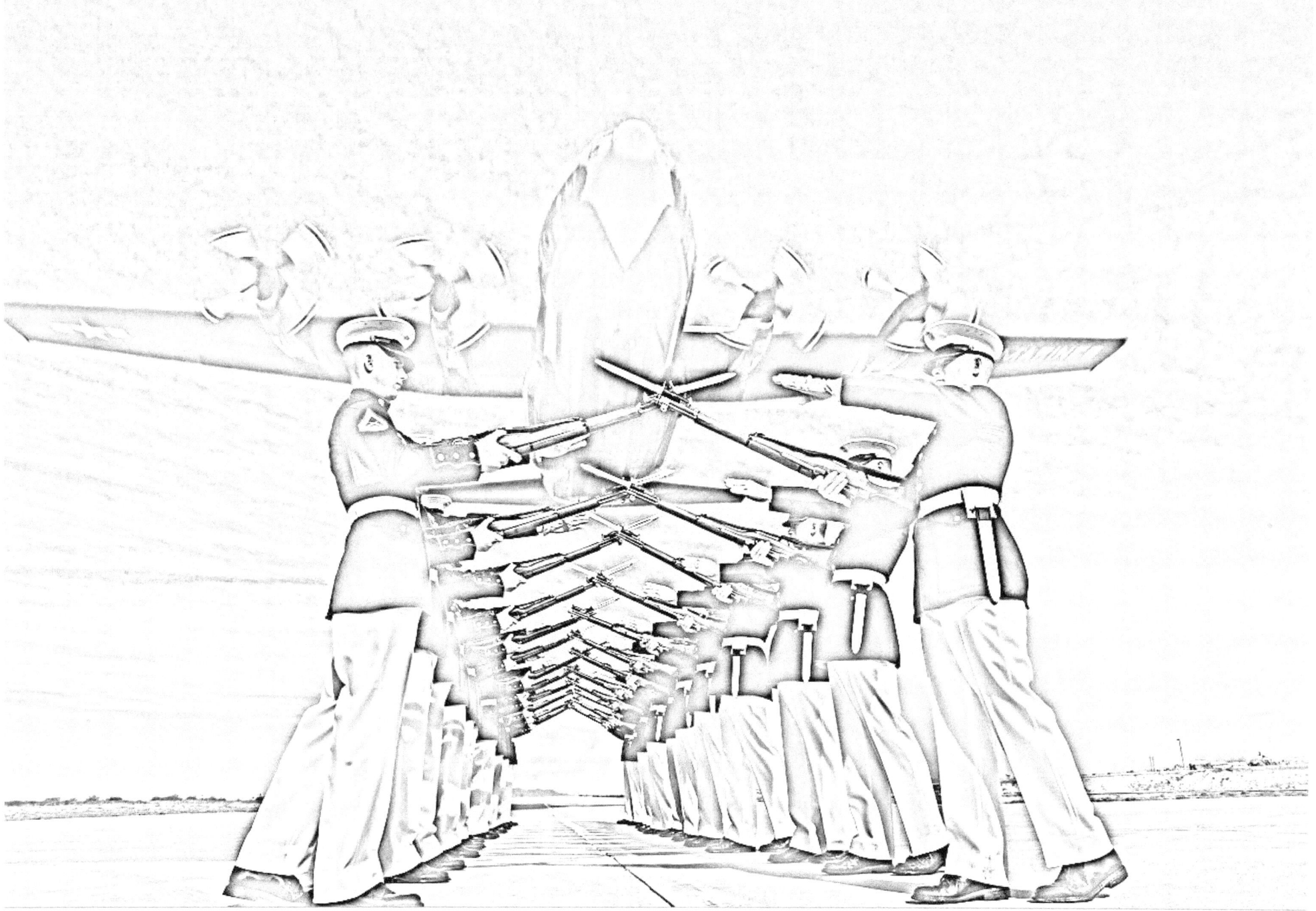

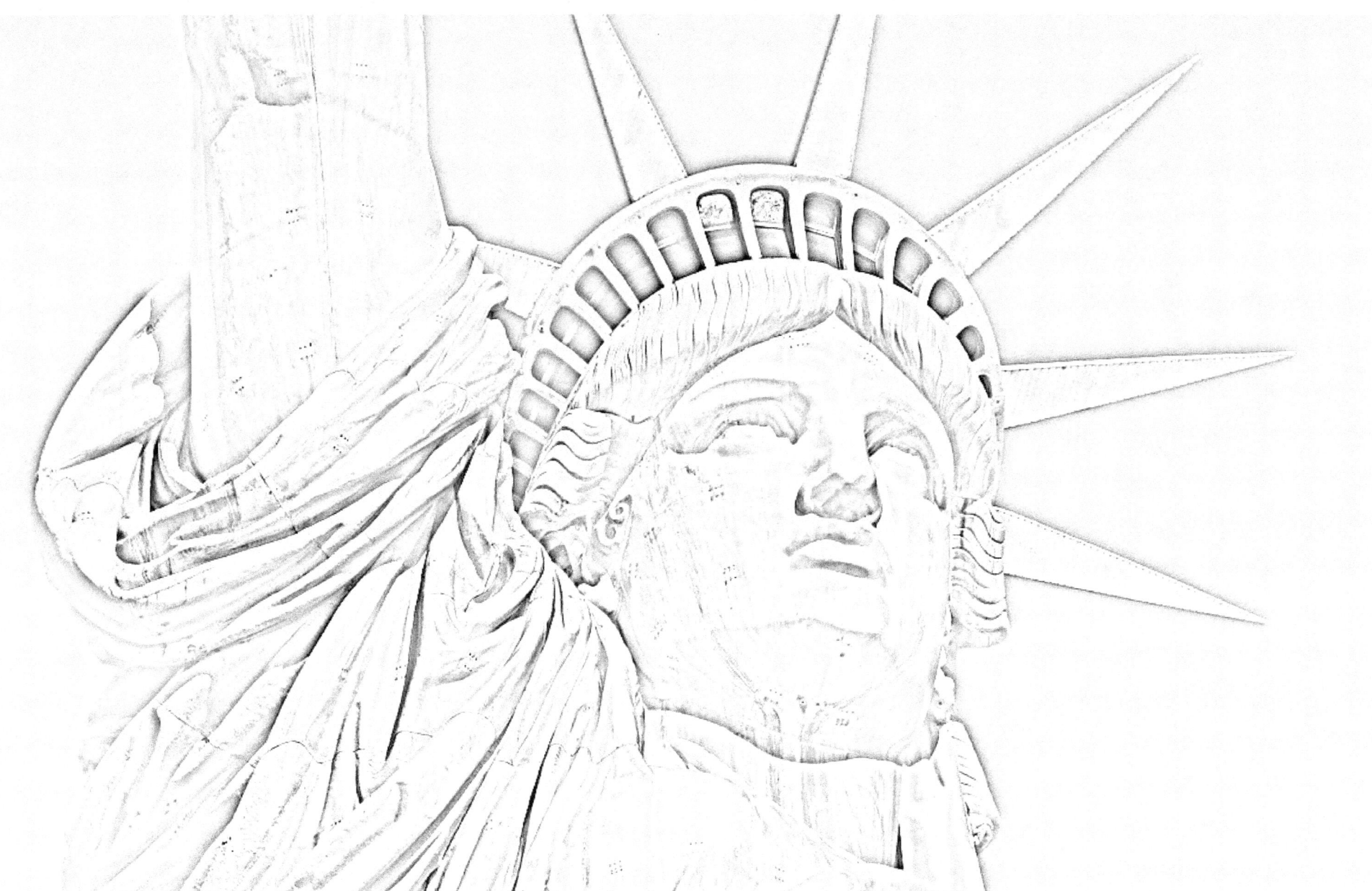

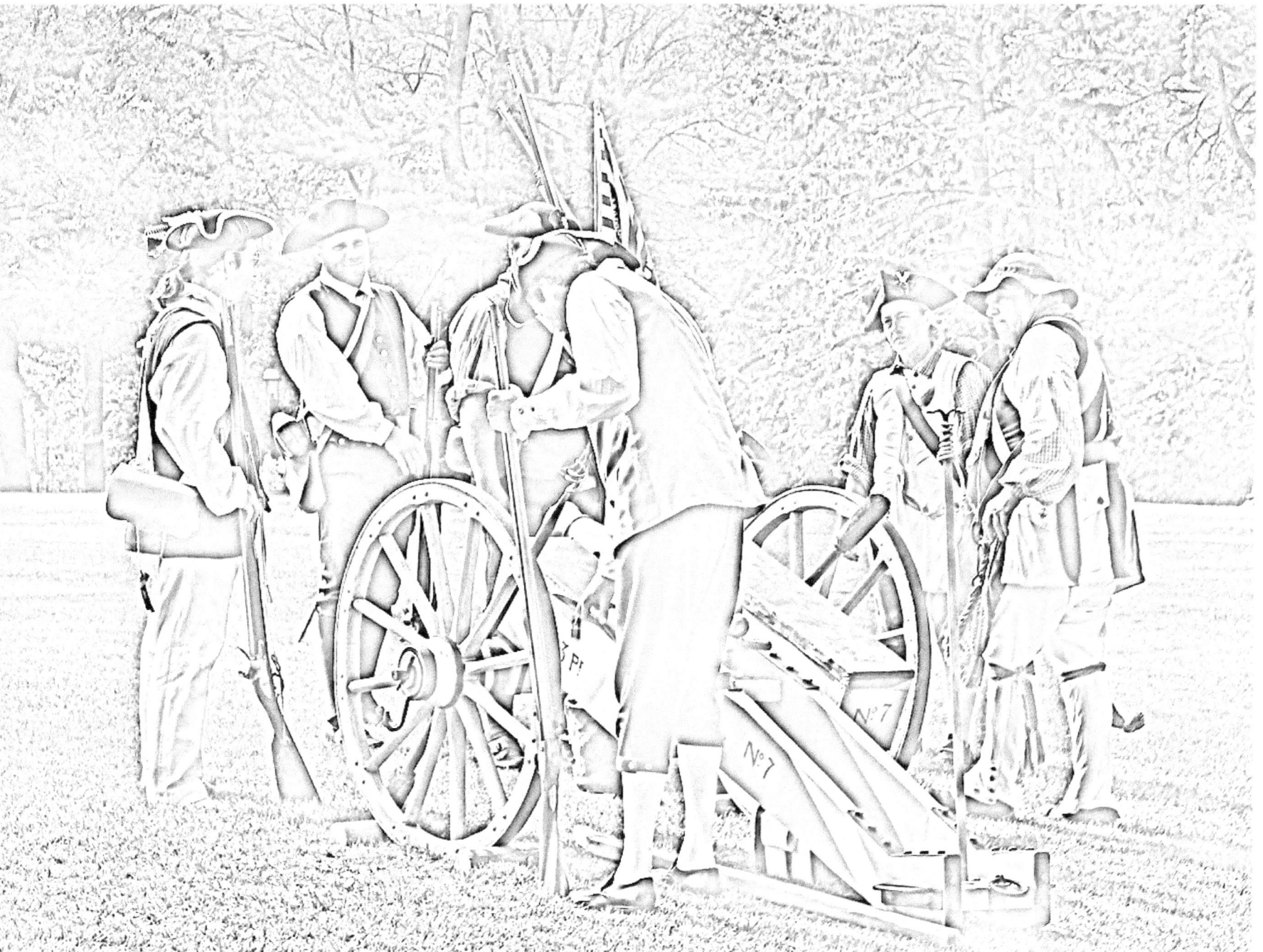

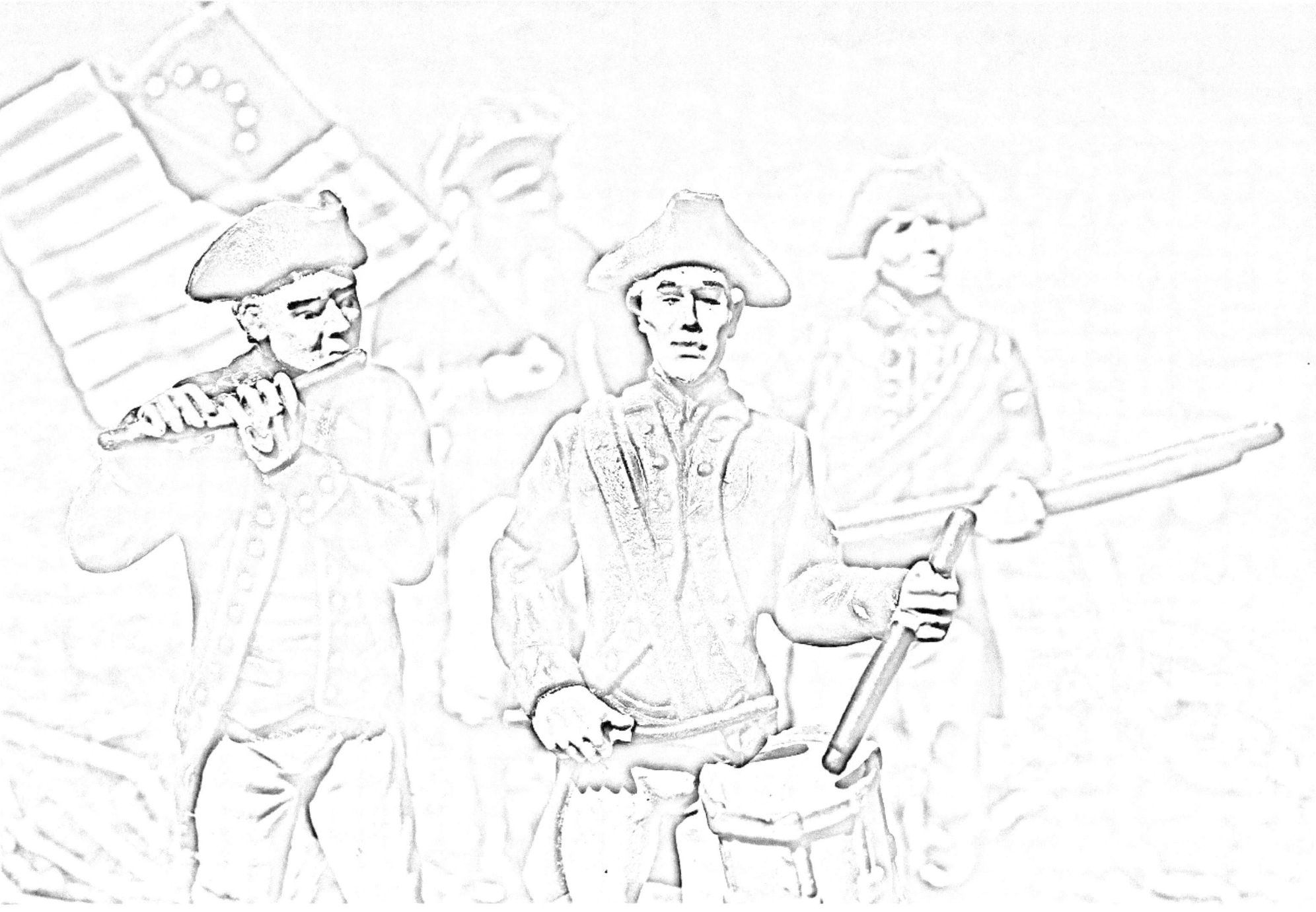

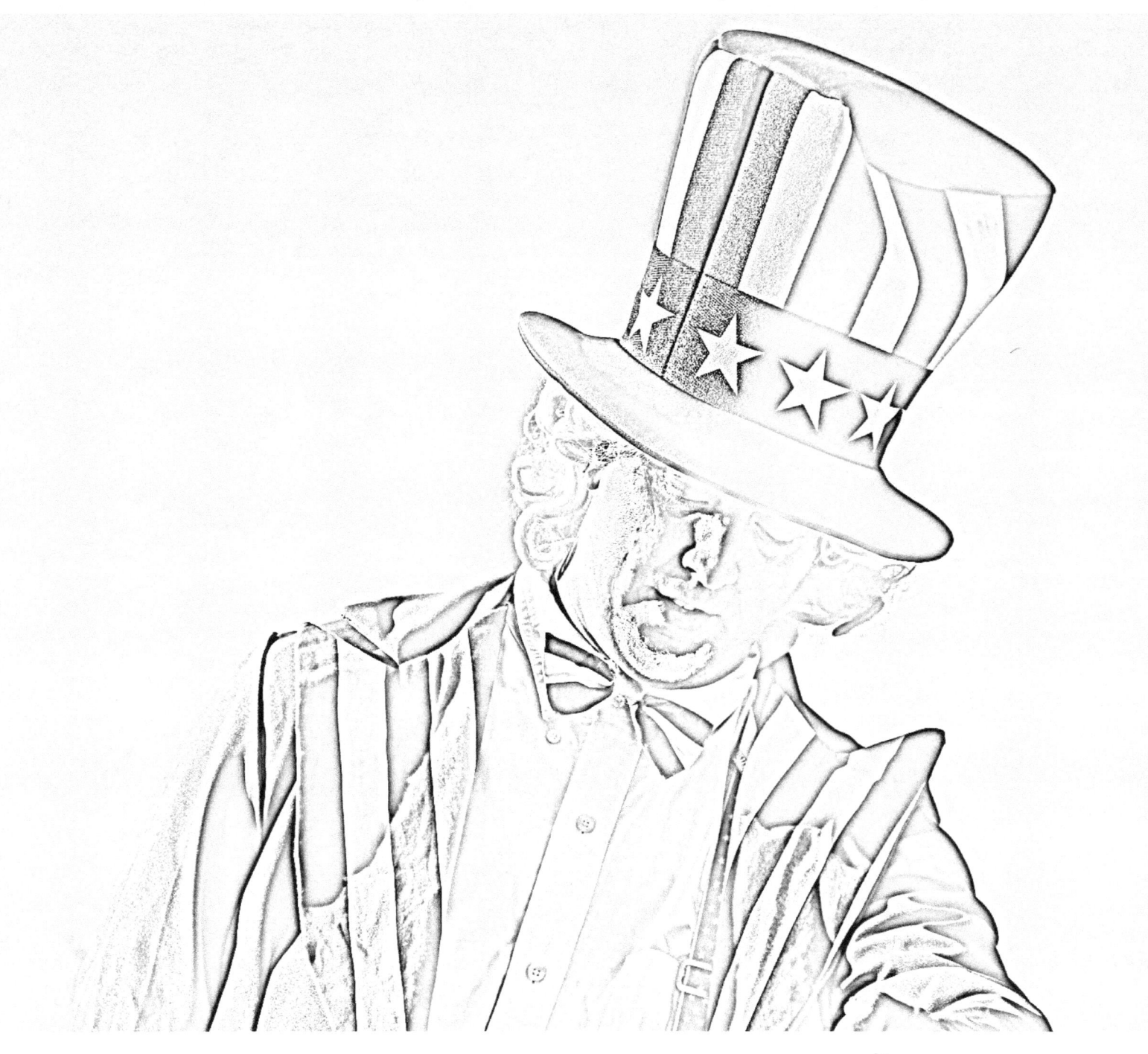

THANK YOU VETERANS

Thank You!
We hope you enjoyed our book.

Watch for more coloring books by ARN Arts LLC.
http://arnarts.wixsite.com/books

www.ingramcontent.com/pod-product-compliance
Lightning Source LLC
Chambersburg PA
CBHW080629190526
45169CB00009B/3336